Robert E. Smith

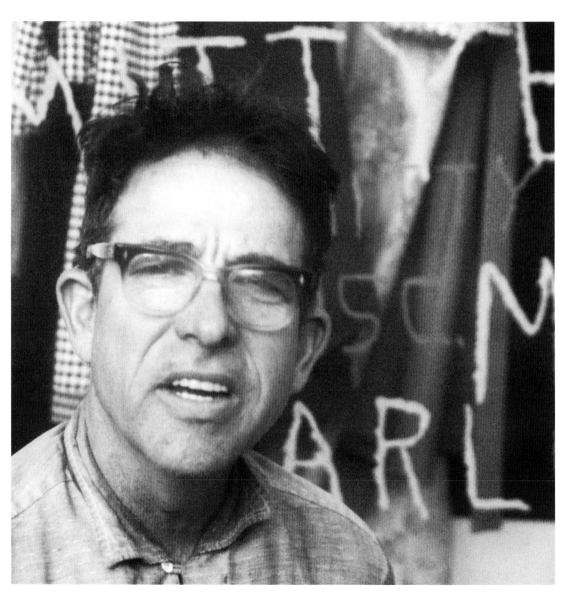

Robert E. Smith

edited by Eric Pervukhin and Carla Stine

moon city press

springfield missouri

2011

Library of Congress Control Number: 2011933886

ISBN: 978-0-913785-02-7

Book design by Eric Pervukhin
Cover design by Carla Stine
Cover illustration: untitled painting (detail) by Robert E.
Smith from the collection of Dwaine Crigger
Frontispiece and back cover photos by Martin Griffin

Printed in the United States of America on acid-free paper

∞ The paper used in this publication meets the minimum
requirements of the American National Standard for
Information Sciences–Permanence of Paper for Printed
Library Materials, ANSI z39.48-1992.

www.mooncitypress.com

The editors of this book would like to thank the following people for their contributions:

Sally and Rob Baird
Jim Baumlin
James Beasley
William "Bucky" Bowman
Mary Ellen Collins
Dwaine Crigger
Jacqueline Findley
Tonya Forbes
Martin Griffin
Jeff and Marcia Johnson
Grace Matthews
Becca Rutledge
Tony Toste
Stacy Tweston
Ed and Nancy Wagoner

Introducing

Robert E. Smith
(1927-2010)

Exuberant. Magnanimous. Fun. Crazy. Colorful. Free spirit. Non-conformist. Larger than life. When envisioning the artist Robert E. Smith, these words immediately come to mind for those who knew him. Much has been said about the fine line between genius and mental illness, both so common among prodigious artists. Smith was unquestionably one such artist, as the inimitable boldness of his compositions demonstrate. However, to describe what Robert had as an "illness" seems something of a misnomer, for Robert's condition, if anything, enabled him to weather the storms of life with seeming ease. According to his cousin, Grace Matthews, family lore upheld the theory that a high fever caused by the malaria which Robert endured at the age of seven resulted in neurological difficulties that affected him for the rest of his life. By the time he arrived in Springfield in 1975, he had spent the better part of his adulthood institutionalized for what was initially diagnosed as a "nervous condition."

His self-published autobiography describes the 18 years he spent at the mental institution in Farmington, Mo. (beginning in the fall of 1950). At the time, our culture not only stigmatized mental illness, but treated it

as a moral failing. Robert underwent numerous shock treatments, many the consequence of his fumbled attempts to escape. Loving life, he longed to experience the larger world. His insouciant disregard for authority and convention became a hallmark of his life and work.

One attempt at freedom occurred in the summer of 1956. Having returned to the hospital from a Cardinals game in St. Louis, he describes the punishments that awaited him:

> ... by the time I got back to Ozark Village at Farmington, it was 2:30 am in the morning. I had managed to get a midnight bus to Farmington. In my walk up the business street Route 32 to downtown Farmington, I had to pass by a city park. Highway 32 ran south of Farmington to St. Genevieve, Missouri. There was a public [rest room] in the park, and at 2:45 am in the morning, most people were at home having pleasant dreams. I went in the [rest room], closed the door, sat down on a toilet stool, and slowly drank half of my bottle of vodka. I didn't care for any more, so I deposited it in a trash can. I walked about three blocks farther west on the business street and came to a gas station that was closed but had a soda machine. I put in some change and got my favorite soda out, some root beer to erase the horrible vodka taste. I didn't care for soda too much. I didn't walk much farther till I came to a little street where the taxi cab stand was, about a one-half block from the St. François Hotel. It was about 3:10 am. I told the cab driver to take me to Cottage Five at the State Hospital. I wasn't able to talk like I was sober, and the cab driver looked at me and scratched his head. He left me off at the front

side of the building and said, "take care, Smitty." I knocked on the door and the night attendant came and opened the door and looked at me in surprise and asked, "Where in the world have you been? You were due back from your job at 6 p.m. They have been out looking for you." Not only was I tired, but I wasn't able to stand and talk like I was sober. I told him, "I had fun and I went up to St. Louis to see a ball game. I guess I drank too much. I'm going to bed." "Oh, no, you're not," said the night attendant. "I'm calling the night supervisor, and he is coming down to talk to you." The night supervisor came down to the cottage row in a few minutes and asked, "Well, Bob, what happened to you?" I told him I lost my job, and I went to St. Louis to celebrate to feel better. The supervisor said, "Well, we're going up to the clinic so you can calm down after your celebration. " I guess I was at the clinic till the third week of July of 1956, undergoing a series of six or eight shock treatments for my drunken behavior. I was assigned to the Dockery ward, a locked ward on the Cottage Row when I left the clinic. I would be on a locked ward for three years before I would be transferred to the Gardner Ward, another open ward next to Cottage Five, with a ground parole and town privileges. I didn't start to work in the kitchen again till September of 1956. I had been locked up on the ward for six weeks before I got a chance to go out on a work detail again.

It is to his credit that Robert was able to maintain his individuality and self-respect, in spite of his lengthy stay and given the conditions of mental institutions in the '50s and '60s.

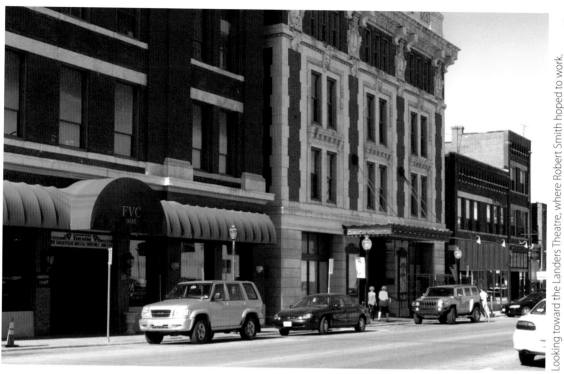

Prior to discovering drawing and painting as a creative outlet, Robert expended much of his energy and time on music; listening, playing, singing (in the easy, crooning style popular in the 1940s and 1950s), and volunteering in the music studio which broadcast a radio program on Friday evenings in Farmington. He taught himself to play the harmonica and the melodica (also known as a "key flute"), and established himself as an

amateur entertainer at the hospital, where he performed at events, often with visiting bands. His interest in music eventually took a back seat to his art, but continued to be an important facet of his life and work. Many of Robert's paintings include some reference to music, either in the form of an accompanying tape recording featuring his singing, and/or of visual references to the music industry. Elvis Presley, in particular, is a recurring character.

In December of 1960, Robert observed a hospital worker making Christmas decorations for the ward. Inspired, he began to dabble in art—a chance moment that would change the course of his life. Soon after, a nurse on the ward took an interest in Robert's new endeavor:

> Miss White, a nurse on the hall who had become a friend of mine, saw my drawing one day by accident. She was surprised but told me about an art class I should get into over at the Occupational Therapy Building where the Music Studio was.
> I told Miss White I didn't think I was ready for the art class yet and that I didn't consider myself a portrait artist like my own dad was, but that I did wish I had a beginner's art book to help me. Miss White told me she would buy me an art book in town.

In the section of his autobiography entitled "Five Years of My Life Not Dramatized or Expressed Enough," Robert explains his attraction to art:

> Looking back I can understand why I got more involved in art work more than music. Almost since birth I was born with a heart condition almost like my own dad. It has needed checking

sometimes. In art work you are away from too much excitement and tension that happen on other jobs. Art work is relaxing, almost like spending a quiet scene in the country. Modern music has too much tension and stress, especially hard rock. Tension is not good for the blood pressure.

Health benefits aside, Robert began to earn money for his art. From the very beginning, his work garnered the attention of hospital staff who bought his paintings. And his paintings—lively, colorful, and filled with images of things that were important to him—demonstrate a clear, consistent vision that he carried through his entire career. Unencumbered by convention, Robert's "outsider" art was intensely, brutally honest from the start, and would remain so.

After his release from Farmington Hospital in 1969, Robert worked a number of odd jobs while attending school part-time and continuing to paint. In August of 1973, he entered two paintings in the Missouri State Fair. The lengths Robert went to in order to enter his paintings (and then go back to pick them up) showed his persistence and determination—qualities that drove him to eventual success:

> I picked me up two drawing boards at an art store in Jefferson City and hoped that with my job at the state capitol I could afford a trip to the state fair in Sedalia and enter my art work in the fine arts Department at the state fair. I had never been to the state fair and I wanted to see some scenery when the fair started in the middle of August.... I kept hanging in there at my job at the state capitol because I needed the money and I wanted to go to Sedalia

in August. I can honestly say working the bottom 1st floor up to the 4th floor [with] the stairways and the elevators was a TIRESOME job some days. I got a chance to tell my supervisor the day I needed off to take my artwork to the state fair before it started on August 19th. I had made some money from selling GRIT papers after I finished work and was at home and besides I was due for a supplementary check the 10th of August. I would get the remainder of my whole check at the end of the month. The Boss gave me August 10th off, the day of my check but reminded me to come in and work on a Saturday. I took my two paintings to the state fair from Jefferson City on August 10th. It was a 60 mile ride from Jefferson City to Sedalia. You might say I had the beginning phase of my folk art paintings, [which] I was trying to circulate around. I had about a 4 mile walk when I got off at the Trailways Bus Station and walked west to the fairgrounds. It was a big place, buildings almost like you see in a small village with a big stadium for different sports events, and a BIG building that was the administration and office building. I got to the fine arts building and filled out my entry cards and tags, price and title of the paintings...

After a visit to Springfield in September of 1975, Robert came back to his basement apartment in Columbia, where "conditions were not pleasant or nice," and to a boss and co-worker who harassed him. He then had "a crazy idea to move to Springfield [to] find another job and try to audition at Landers Theatre and get some play acting experience again." One month later, armed with two trunks, six paintings, and his pet parakeet, Elvis, he made Springfield his home.

The ascent of Robert's career as a professional artist was anything but glamorous. Several hundred pages in his autobiography describe the many and varied jobs he held, countless apartments he rented, bus trips he took, and hardships endured, all explained matter-of-factly. His tenacity paid off, though, and in the late '70s and early '80s he began to attract the attention of galleries and art dealers. Leland and Crystal Payton, a couple in Sedalia, Mo., appreciated his work and began selling Robert's paintings during their travels.

> A letter had come to me from Leland and Crystal Payton and they would be down to see me the middle of January buy my few paintings from me so they could sell them on a trip to California take me to the NATIONAL ART SHOP and buy me some paints, brushes, drawing pens and about 6 drawing boards to keep me busy for awhile. When they arrived in January, a week before school started, it seemed like a new beginning for me.

As his popularity grew through the '80s and '90s, fans clamored to acquire custom-made paintings; always, however, Robert's distinct interpretation of content was entirely on his own terms. Although willing to include specific ideas or representations, his custom work never veered from his novel approach to visual narrative. But it wasn't the paintings alone that compelled people to buy; purchasing his work often included the bonus of meeting him and seeing the personality that reflected the whimsy and purity in his art. And when Robert met someone, rarely did he forget that person.

At the heart of what inspired his art was storytelling. (His autobiography is nearly 500 pages.) Storytelling, perhaps, was the means by which

Robert organized his thoughts and made sense of life. This visual folk-lore—rich in irony, wit, and adventure—captivated would-be buyers of his work. Many of his paintings include a hand-written story explaining the composition. In 1983, Robert's friend, Martin Griffin, suggested that he also include a cassette tape recording of him reading the story; replete with sound effects, this became an additional bonus.

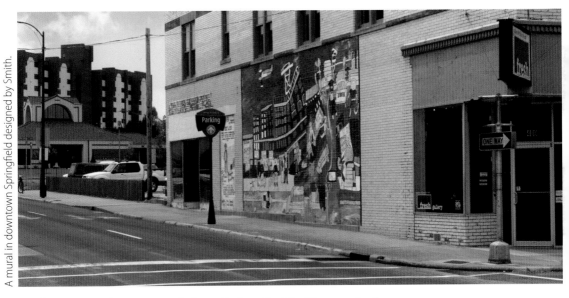

A mural in downtown Springfield designed by Smith.

There was nothing nuanced about Robert Smith. He was who he was and saw no need for apologies. He has been called "high maintenance," "demanding," and "imposing." Anyone else possessing such qualities would probably be considered annoying. But the way he conducted him-

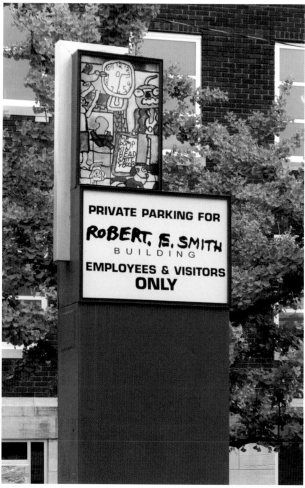

This building was named for Robert Smith by its owner Nick Sibley, an ardent fan.

self was unintentionally endearing. For example, he might see an acquaintance while walking down the street and presumptuously tell that person he needed a ride to the post office (or bank, grocery store, etc.), with the full expectation that said person would drop whatever he/she was doing and run him to wherever he needed to go. His demands weren't buttressed with an anger born from insecurity. He was simply expectant. As his friend Christine Schilling once observed, Robert "upped the ante. Whatever you thought you might be doing, Robert was bigger, bolder, and more honest." Perhaps Robert's true genius lay in his singular fearlessness in facing life head-on, and how this informed his process is what gave his work such energy.

Though Robert gained international fame as a folk artist, he remained true to his Midwestern roots. A stroll through downtown Springfield shows the deep imprint he left on the city, both in the murals and in the building bearing his name. Reinventing folk art on his own terms, he turned downtown Springfield into a canvas reflecting his own artistic vision. Even with his passing, Springfield belongs to Robert E. Smith. Robert's work has enriched the lives of people all over the world, but in Springfield, Missouri, Robert himself sculpted a niche that gave shape to the culture of the community.

Carla Stine, June 2011

Church Tractor Pump
ca. 1975
mixed media, 20 × 16"
from the collection of Dwaine Crigger

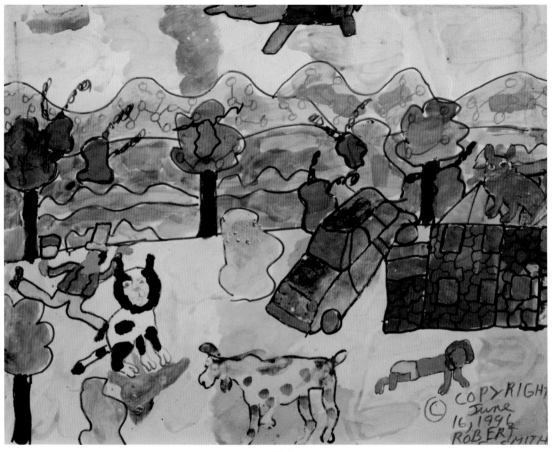

untitled
1996
mixed media, 20 × 16"
from the collection of Leslie Dawson

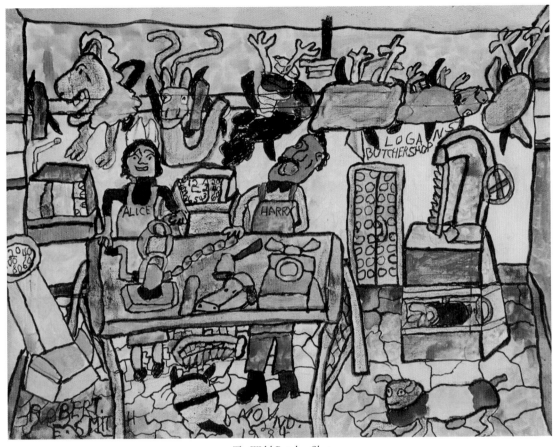

The Wild Butcher Shop
1984
mixed media, 18 × 14"
from the collection of Martin Griffin

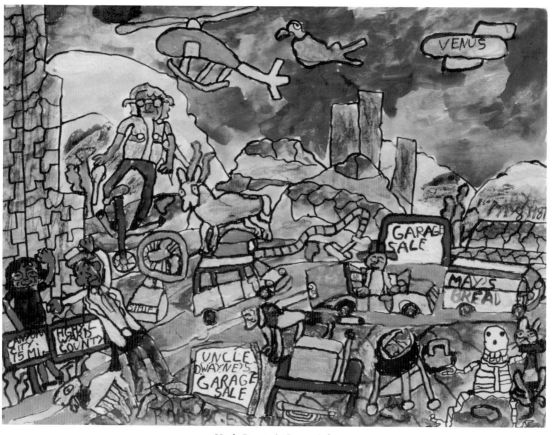

Uncle Dwaine's Garage Sale
N.D.
mixed media, 20 × 15"
from the collection of Dwaine Crigger

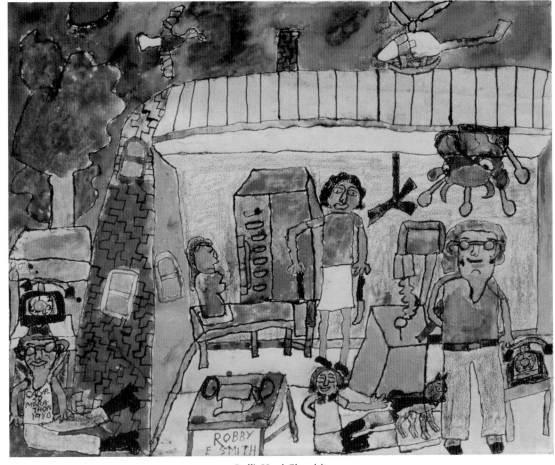

Bull's Head Chandelier
1980
mixed media, 20 × 16"
from the collection of Dwaine Crigger

Where Is Santa?

It was a Dark Christmas Eve night; The wind was cold and there wasn't much snow in sight. Everywhere on the ground, grass was green; it was a spooky and quiet type of night! Almost like some drama on Radio Mystery Theatre; There was an Auto Salvage Junkyard with a red brick wall on each side; Wrecked cars were scattered here and there, some piled on top of each other. By the Junkyard was a fence and a small cemetery that gave one a scare; There were graves with names of dead people who were born and died. In one part of the cemetery there were clothes that definitely belonged to Good Old St. Nick. One would think it was a dream and they needed a swift kick. Red Pants, a Red Coat and Red Cap lying on the cemetery ground. It sort of made your head go 'round and 'round. Where is Santa? Where is Santa? A rabbit was in the cemetery eating grass. Behind the cemetery there was a cow, horse and deer. The cow pasture was a view that seemed to draw one near. In the dark but moonlit sky, a silver balloon flew, advertising Merry Christmas. Two birds flew in space but Santa was not in sight. Where is Santa on this Christmas Eve night? Where Is Santa? Poor Santa must have met with foul play. The clues are as sound as night and day. On a road running by the junkyard and cemetery lay Santa's Red Boots. Santa's sled was at the edge of the road leaning against the brick wall and fence of the cemetery. Jane's Bakery Station Wagon drove by on the gravel road. The station wagon had a real heavy load. Next came a sports car pulling a trailer. St. Nick's reindeer were not even near—Where is St. Nick who brings Christmas cheer? Where is Santa?

A prose poem by Robert Smith.

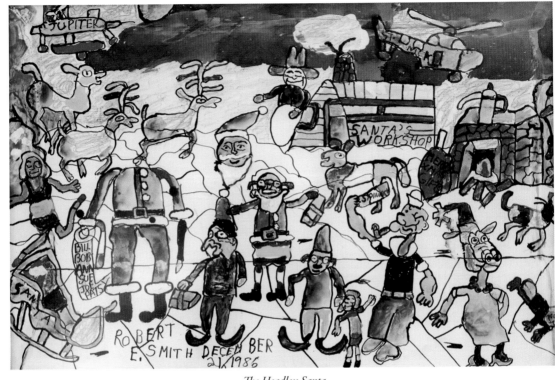

The Headless Santa
1986
mixed media, 24 × 16"
from the collection of Martin Griffin

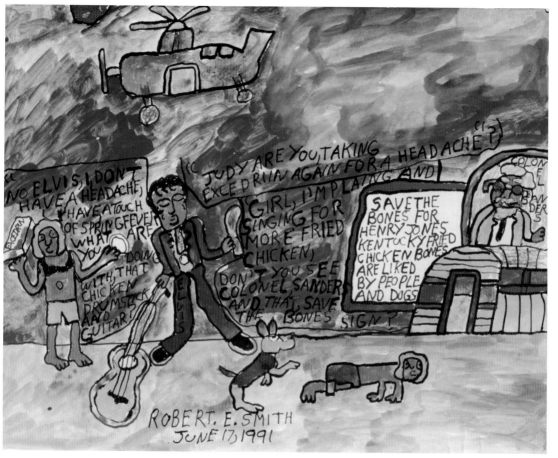

untitled
1991
mixed media, 20 × 16"
from the collection of Dwaine Crigger

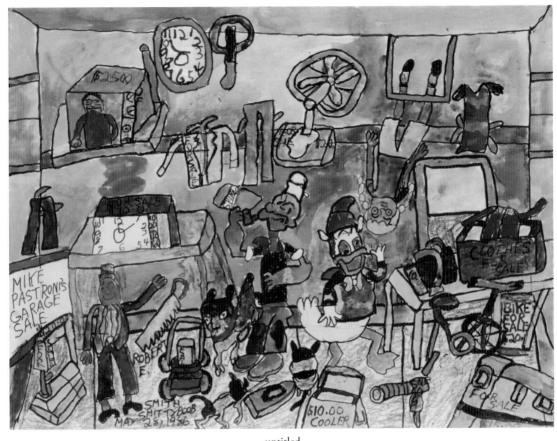

untitled
1986
mixed media, 20 × 15"
from the collection of Dwaine Crigger

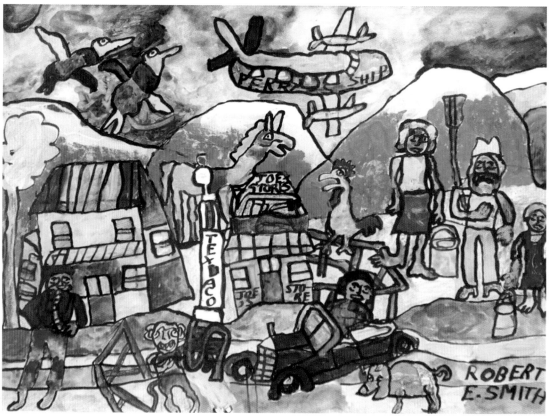

The Hill People
N.D.
mixed media, 19 × 15"
from the collection of Martin Griffin

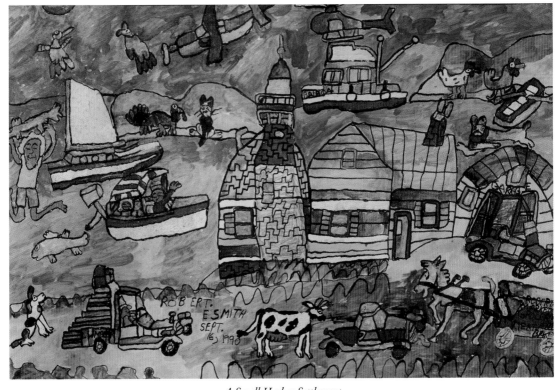

A Small Harbor Settlement
1990
mixed media, 30 × 20"
from the collection of Tony Toste

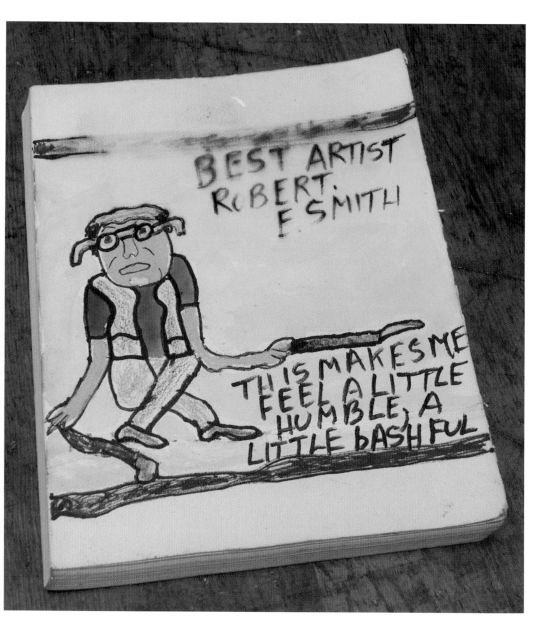

...well I had a little money with my supplementary check and the girl waitress whose name was Brenda and had got acquainted with me and sweet on me at Frank's Cafe had even driven me home in her car a few times from work. I wanted to please her and registered at an automobile agency to take a few driving lessons and at least a driving permit, but I still had difficulty in passing the test because of my vision and neck injury that happened to me when I was 18 months old back in 1929. I should have had all of my $700.00 at Ozarks Federal Savings and Loans in Farmington transferred to a bank in Columbia because I would need it for cashing future payroll checks from the hospital I worked at. However I did what I consider was a foolish idea now. I withdrew 500 dollars from the savings account leaving still $200.00 in the account. I went out to a used car lot and bought a used car, a 1964 model called a V-8 Oldsmobile. I was required to drive the car home, but to get a license as soon as possible. The car wasn't too much of a problem to drive, it had registered 80,000 miles of travel. The switch that turns on the engine needed repair work. Brenda took me out a couple of times to try to help me drive the car better, and then she was gone for awhile. I didn't know what to do. I failed to pass the driver's license test and was having problems driving the car myself. It was around my birthday, October 14th, and I had left my car in the parking lot next to the apartment house for a week. The landlord told me if I wasn't driving it, I would have to find some other place to keep it, because other residents in the apartment needed space to park their cars. Well, I didn't have another place to keep my car, so it came down to where I would have to sell the car to someone.

A passage from his self-published autobiography describing the one and only time Smith drove a car.

Farm
2005
mixed media, 14 × 11"
from the collection of Becca Ruteledge

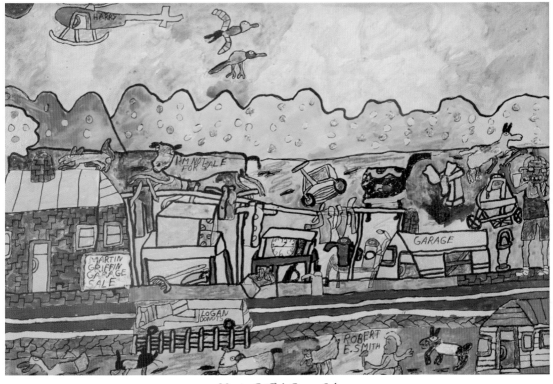

Martin Griffin's Garage Sale
N.D.
mixed media, 30 × 20"
from the collection of Martin Griffin

February 1, 1987

Robert E. Smith
627 E. Elm St. apt. 2
Springfield, MO 65806

Dear Robert,

Thank you for your interest in LATE NIGHT WITH DAVID
LETTERMAN.

We reviewed your material at a recent talent meeting.
Unfortunately, we don't feel an appearance would be quite
right for our format at this time.

Thanks again for thinking of us.

Sincerely,

Sandra Furton
Head Talent Coordinator

A letter from LATE NIGHT WITH DAVID LETTERMAN declining Robert's request to appear on the show. In defiance of anyone's agenda but his own, Robert managed to populate the local press and, occasionally, capture the attention of larger audiences.

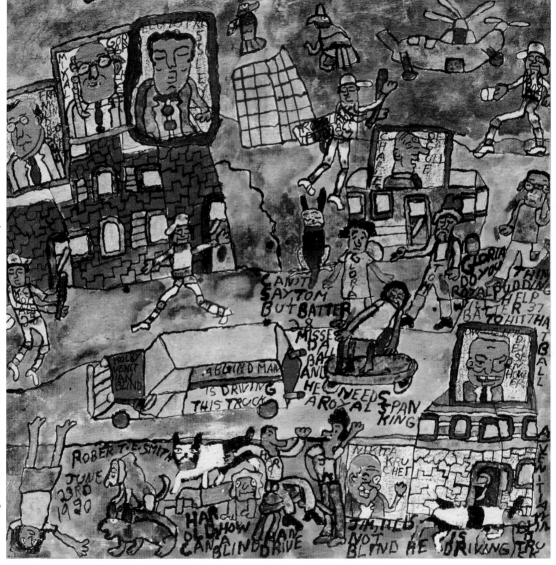

Famous People, 1990, mixed media, 24 × 24″, from the collection of Tony Toste

35

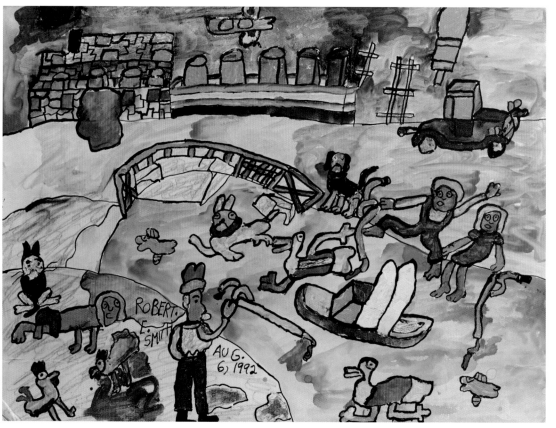

Stockton Lake
1992
mixed media, 24 × 18"
from the collection of Tony Toste

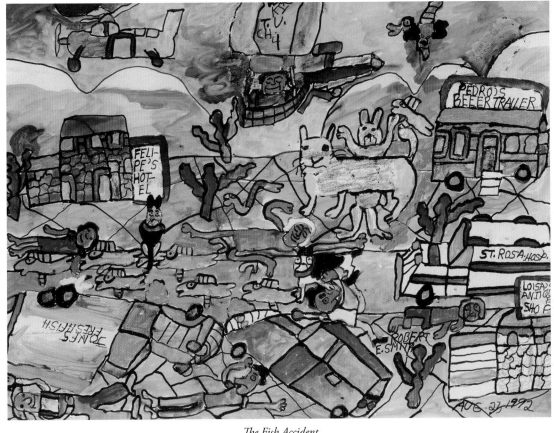

The Fish Accident
1992
mixed media, 24 × 18"
from the collection of Tony Toste

The Terrible Number of Drunken Drivers

Going down the sidewalk it seems everyday some driver is turning the corner too fast or too short of a turn. Later on, a pedestrian walker hears the screaching or squeaking of brakes or rubber tires. One can't wait 'til daily chores are finished and they are at home in the house. The streets are terrible to be out on. An individual thinks what is that crazy driver going to do next. It would surprise nobody if the driver wound up on the sidewalk instead of the street and often the car does run into a lamp post and drivers of cars that seem like foolish driving almost cause a pedestrian heart failure from fright. As in most cases, many of these foolhardy drivers are not sober and showing off, but intoxicated or under influence of drugs.

Just a glance at the Daily Newspaper will show you the number of DWI drivers arrested. It is a terrible number. This should be a warning to the reader that even being too careful is not a sure thing. The figure in Newspapers on drunken drivers arrested seems to indicate a mounting toll most of the time and that you must be on the lookout for the unexpected, because they won't watch for you. It seems the best thing ever printed in a paper.

A prose sermon against drunk driving, from one of Smith's self-published books.

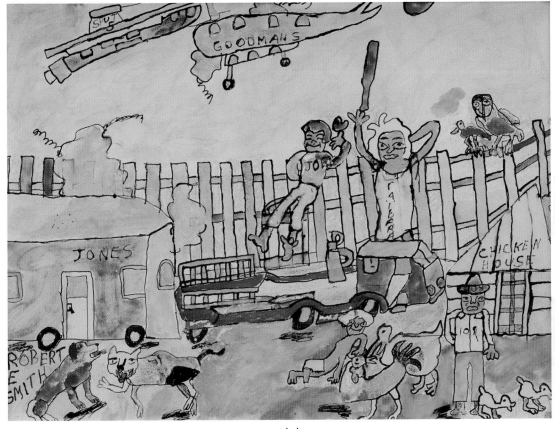

untitled
1979
mixed media, 24 × 18"
collection of Jeff and Marcia Johnson

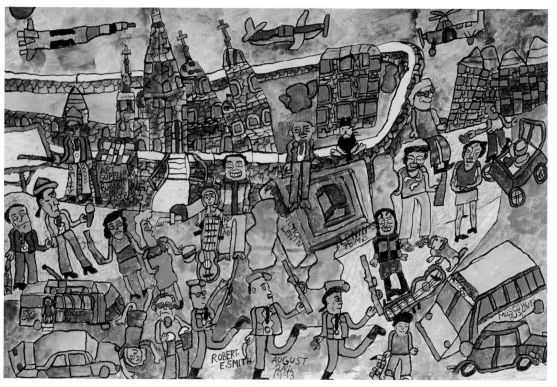

Red Square Moscow
1993
mixed media, 36 × 24"
from the collection of Tony Toste

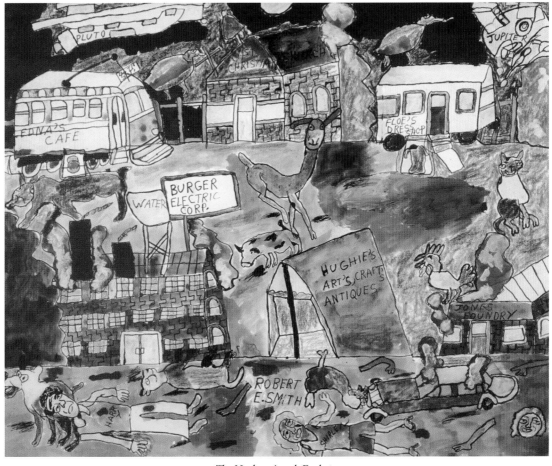

The Nuclear Attack Explosion
N.D.
mixed media, 24 × 20"
from the collection of Martin Griffin

Text visible within the artwork:
HARRY'S MOBILE BARBERS
JONATHAM
WILD LIFE PARK
ROBERT. E SMITH
KY 3-T
SHIRLEY CARTER
RAT PATROL

Shirley Carter's Garage, N.D., mixed media, 20 × 20", from the collection of Craig Wagoner

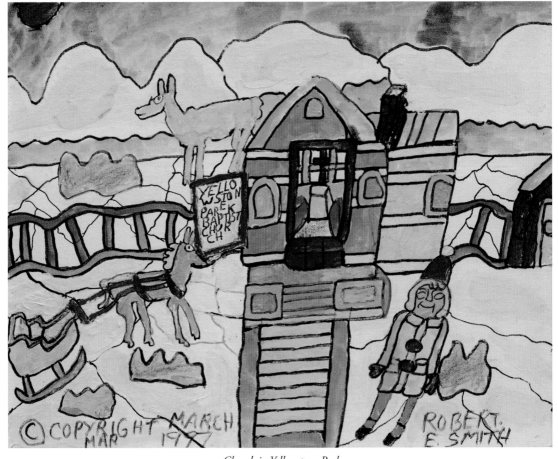

Church in Yellowstone Park
1997
mixed media, 20 × 16"
from the collection of Rob and Sally Baird

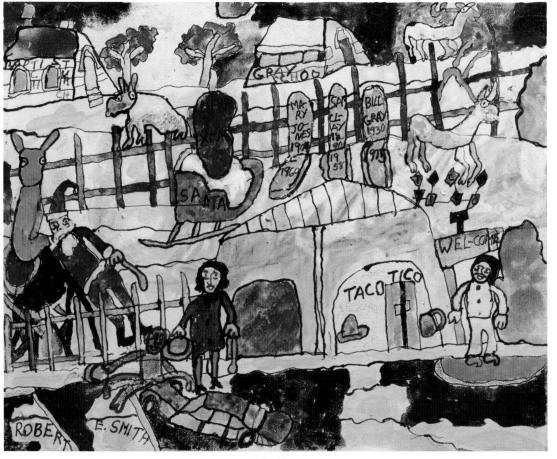

Taco Tico
2004
mixed media, 20 × 16"
from the collection of Craig Wagoner

A story accompanying the painting on facing page. This is an example of Smith's hand-written narratives.

Taco TICO AT Christmas

The Scene
of this Painting
makes one ask
What is This
well it is the eating Place
Taco Trco. Linda stands
outside in Her Blue Dress
in the Cold air Holding a
Silver Plate and spoon
waiting for the Restaurant
TO open A Small sports
Car is Parked in front of
Linda and Herman the
Ape next To Linda who is
Also Holding a silver Plate
waiting for the Restaurant
TO open The street is Half
Covered with white Snow
Blocks and The Street Parking
Lot is Black - the Sidewalk
is White Snow Rogers stands
on the other side of Taco Trco
By The welcome sign and
a green Bush. On one side
of Tacio Trco are Mural
Designs of a Hat and Water Pitcher

It must be Close To Christmas Jolly old ST. NICK is inside of a fence and snow Covered yard by Taco Tico, Santa doesn't seem To be Paying attention To Taco Tico, He must be Hungry, He is leaning against a Black Kettle of Boiling Blue Water with a few Logs and fire under it Holding a Spoon and seems To be Cooking a Big Duck Head and neck. Only Two of ST. NICKS Reindeer seem To be in sight and Santa's green sled with a Red Christmas Bag of gifts is in the sled. Three Tombstones with Dead People's names are in this yard. A Rabbit is in a Snowy yard on the other side of the fence, With a White Church, A School and two Trees.

Robert "E. Smith

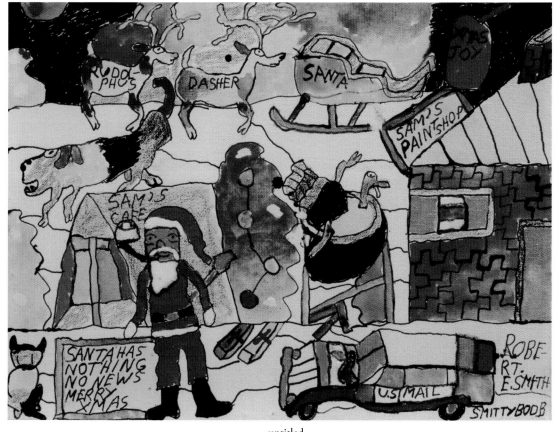

untitled
N.D.
mixed media, 16 × 12"
from the collection of Dwaine Crigger

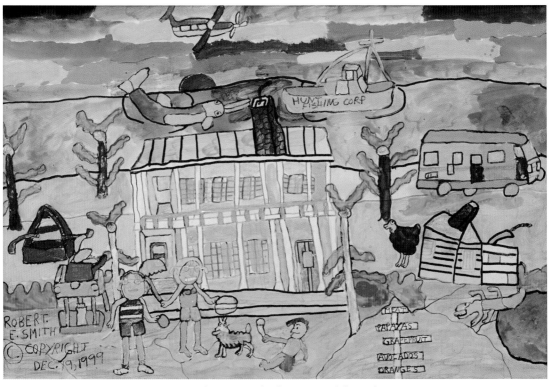

Mr. Robert M. Baird at his House with his Wife
1999
mixed media, 36 × 24"
from the collection of Rob and Sally Baird

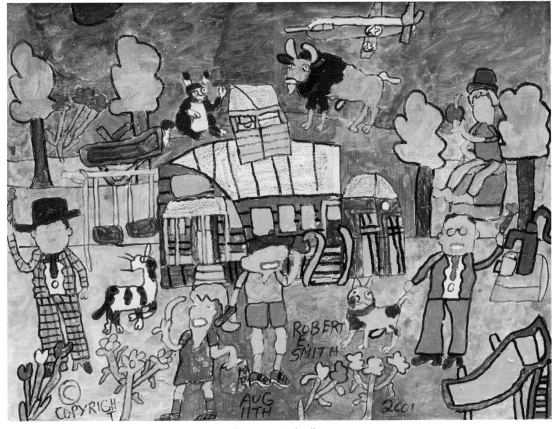

The Country Schoolhouse
2001
mixed media, 24 × 18"
from the collection of Rob and Sally Baird

The Greatest Shortstop in Baseball

Name the greatest shortstop in baseball,
Put on your thinking cap, baseball fan, and try to recall.

In the game he is a wizard,
As stunning as a winter blizzard,

His name is Ozzie Smith,
My name, amigo, is Robert E. Smith.

The wizard is some acrobat and makes double plays galore,
Makes it hard for the other team to score.

Ozzie turns somersaults up and down,
The wizard has more charm than a circus clown.

Yes, Ozzie is sharp on stealing those bases,
Makes one excited like at some horse races.

A tribute to Ozzie Smith,
From me, the artist, Robert E. Smith.

I would like to draw Ozzie, the wizard,
It could cheer me up in a winter blizzard.

We wish you good luck, Ozzie,
You know we do, how could anyone ever forget you?

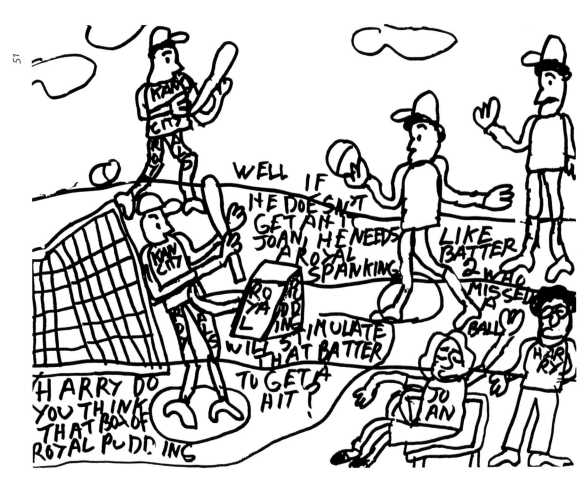

Royal Pudding to Stimulate Kansas City Royal Baseball Player to Hit a Ball
c. 1993
pen and ink, 8 × 6"
from the *2nd Book of Cartoons* by Robert Smith

Oh Those Dead Birds

The St. Louis redbirds are deadbirds
It doesn't make me feel good
I feel sad I won't talk won't do anything right like I should

Oh, those deadbirds what a horrible dream.
The idea gives me a chill and I start to scream;
My writing is not like Mark Twain
Most editors don't think I have a literary brain.

Concerning art will never be a Rembrandt
an object or scene is inspiring;
just too dumb to say I can't

Oh, those St. Louis dead redbirds—
Don't like hearing those sour words.
Dead birds don't make me happy—

A turn of events can only make me slaphappy—
So here's a closing verse;
Forgive me I hope it isn't worse—
Let's hope that fortune will be good after ten horrible years
There will hardly be anyone with tears
Come on you dead redbirds. Come alive.
I'm not eighty yet and I want to survive.

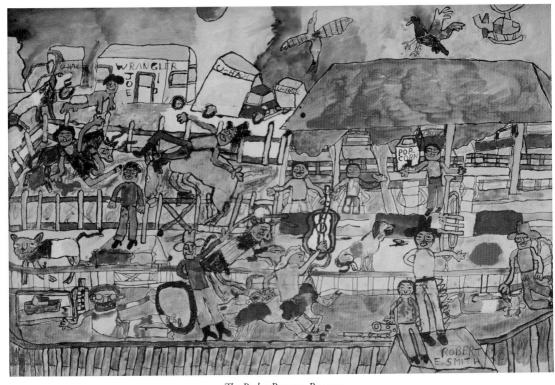

The Rodeo Rumpus Bumpus
N.D.
mixed media, 30 × 20"
from the collection of Martin Griffin

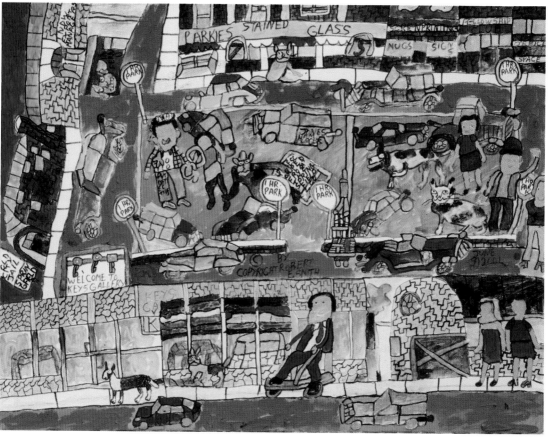

Keys Gallery and Downtown Springfield
2001
mixed media, 30 × 40"
from the collection of Tom Stine

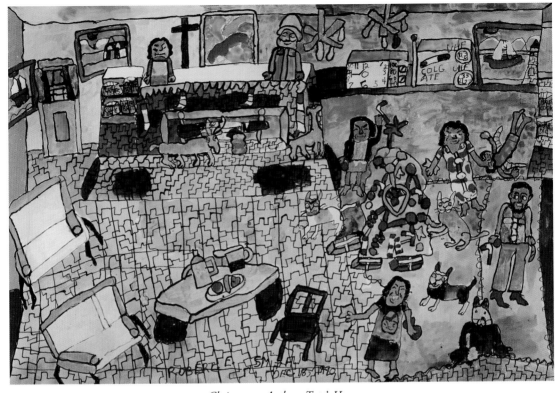

Christmas at Anthony Toste's Home
1990
mixed media, 30 × 20"
commissioned by Tony Toste

ROBERTO SMITHYBOOB IN THE HOSPITAL

a picture story
by
Robert E. Smith

SOLD

The patient in this picture is Roberto Smithyboob but
looks a little like me. He is taking a camera into the
operating room to take pictures of his heart surgery.
The patient on the table is covered with a sheet. There
are many instruments and boxes around him and Dr. Hart
is getting ready to turn on the machine that will perform
the ballon heart surgery. Dr. Burger is listening to the
patients heart. A cart is ready to take the patient back
to his room. Two nurses stand by with water, towels,
bandages and a shot if needed.
Everything one would need is there complete with a orderly,
a janitor, a dog dressed like a doctor, a cat, a pot of
coffee, and food.
Dr. Jim Hart has a very colorful and busy operating room in
which to work.

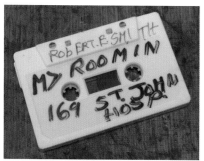

A cassette tape accompanying the painting
on the facing page. Smith occasionally tape-
recorded his stories, adding sound effects.

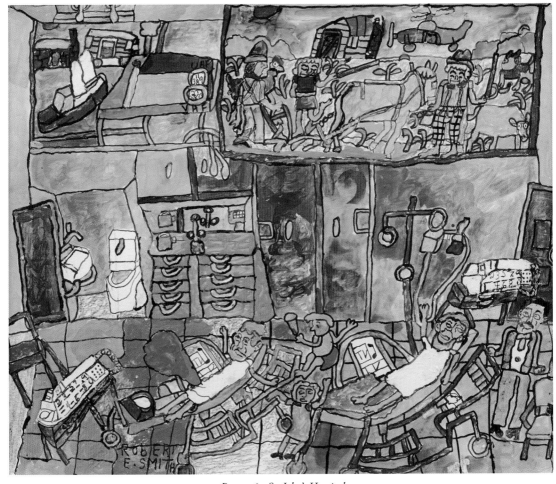

Room 169, St. John's Hospital
N.D.
mixed media, 24 × 20"
from the collection of Jeff and Marcia Johnson

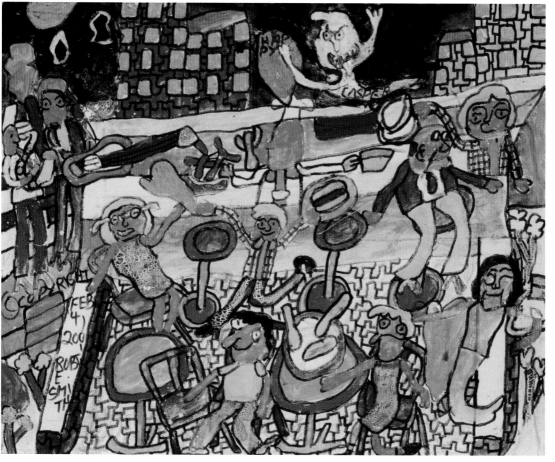

Celebrating Valentine's Day
2001
mixed media, 20 × 16"
from the collection of Becca Rutledge

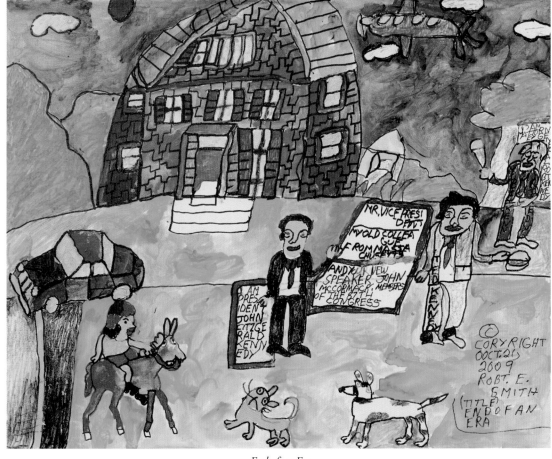

End of an Era
2009
mixed media, 24 × 30"
from the collection of Ed and Nancy Wagoner

...I made a B in the study of United States History at Southwestern Missouri University. My history teacher's name was Mister Lightfoot, but he was not related to Gordon Lightfoot the singer. The history class was especially exciting to me when we were studying about the Civil War. On one page about the Civil War, there was some detail about a Union army officer, he was a captain and his last name was Marion. I don't remember his first name, and few people know this except me and my mother who died in 1990 but this captain Marion was the father of my grandmother on my mother's side. My grandmother's maiden name was Marion before she married my mother's dad William Sinclair Walls who was a Methodist preacher. My grandmother was half Kaskaskiam Indian and half French by her maiden name Marion."

A passage from Smith's self-published autobiography.

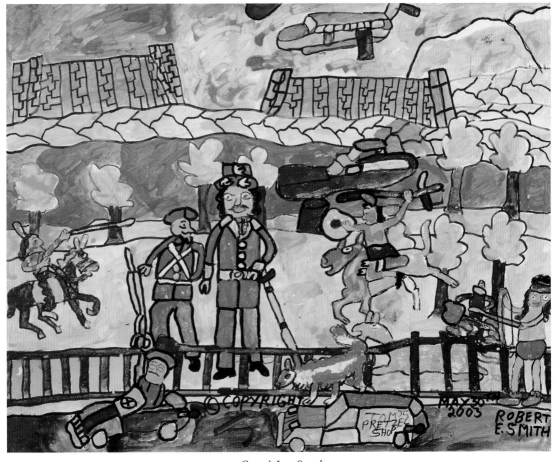

Custer's Last Stand
2003
mixed media, 24 × 30"
from the collection of Ed and Nancy Wagoner

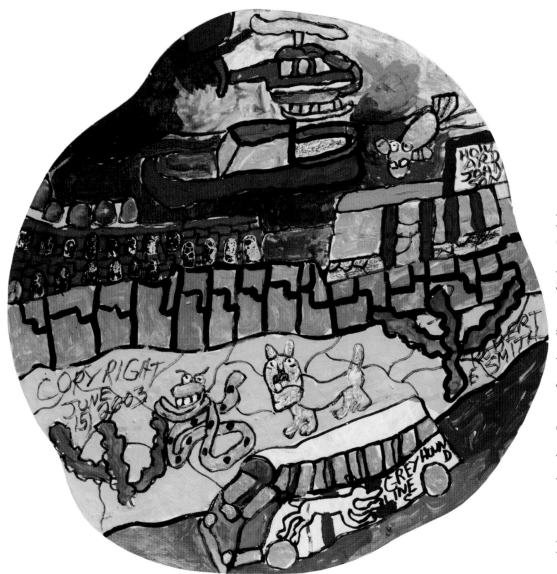

untitled, 2003, mixed media, 17" across, from the collection of Rebecca Rutledge

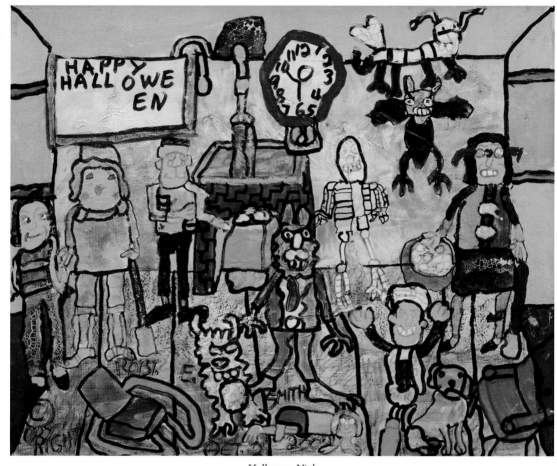

Halloween Night
2002
mixed media, 20 × 16"
from the collection of Rob and Sally Baird

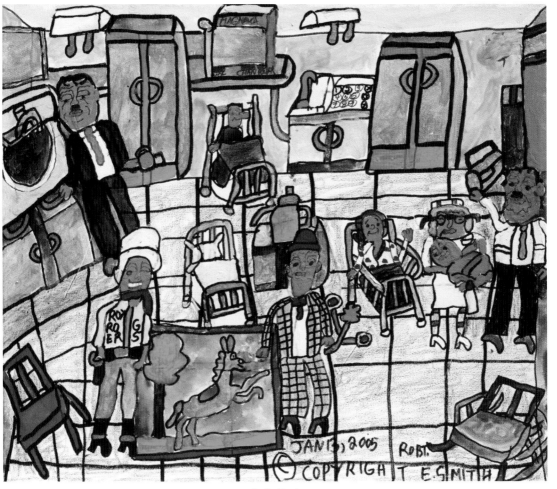

Becky Boob
2005
mixed media, 24 × 20"
from the collection of Becca Rutledge

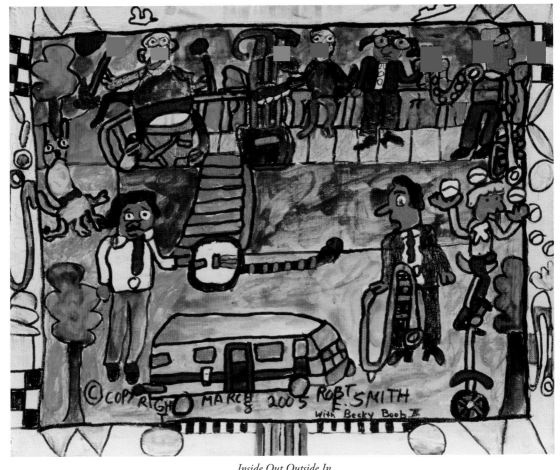

Inside Out Outside In
2005
mixed media, 20 × 16"
from the collection of Becca Rutledge

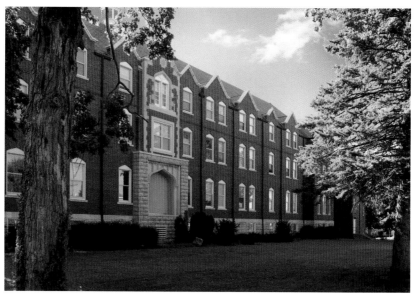

A photo of Franciscan Villa. Smith lived the final years of his life in this low-income residential community.

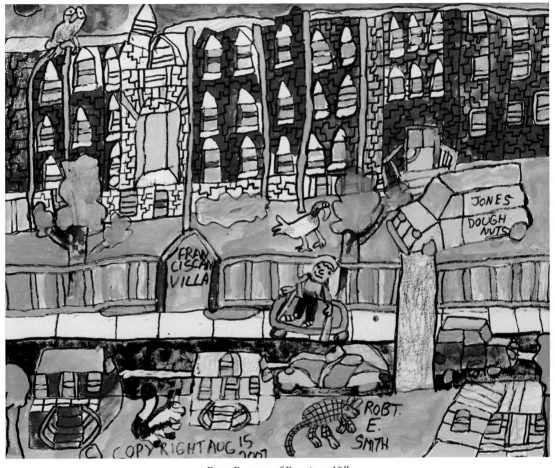

Front Entrance of Franciscan Villa
2007
mixed media, 30 × 24"
from the collection of Jeff and Marcia Johnson

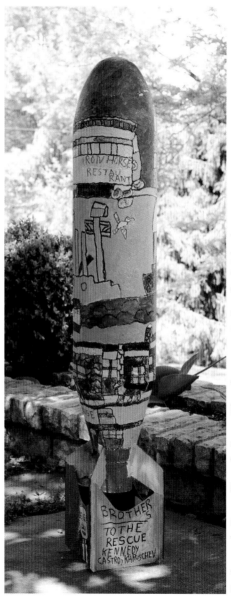

Brothers to the Rescue. Kennedy, Castro, Khruschev, N.D., mixed media, height 4'
from the collection of Stefan and Marie Braid

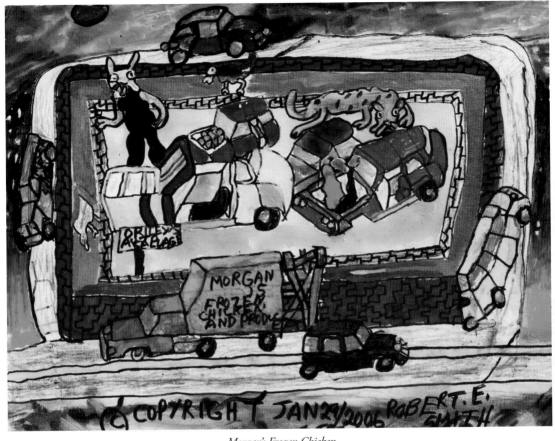

Morgan's Frozen Chicken
2006
mixed media, 24 × 18"
from the collection of Dwaine Crigger

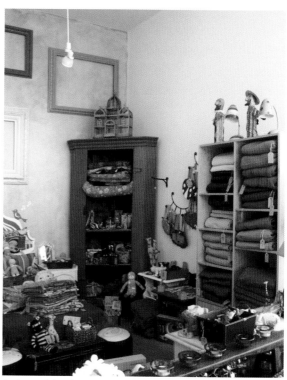

A photo of the shop depicted on the facing page.

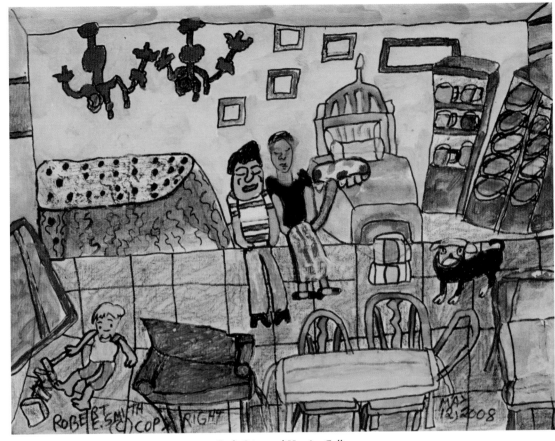

Carla Stine and Her Art Gallery
2008
mixed media , 24 × 18"
from the collection of Carla Stine

Drama On Thanksgiving Day

It was a cold Thanksgiving Day and starting to snow;
The sky was dark in Springfield Mo.
My morning walk to a delicatessen ended with glee.
Suddenly to my surprise on the street was a motorcycle jockey.
I was enjoying my morning tea in 1992.
The rider straddled that motorcycle like he was playing hockey.
Early that afternoon at a friend's house I ate a good Thanksgiving dinner.
Sorry to say the holiday meal wouldn't make me thinner.
Still I didn't eat like some fish eating bait.
My desire was to have strength to walk through the Pearly Gate.
It was a peaceful Thanksgiving day.
There was church services and prayer that could lighten one's way.
Television showed a Thanksgiving spirit oh so gay.
Truly it was drama on Thanksgiving day.

A poem from the self-published booklet, facing page.

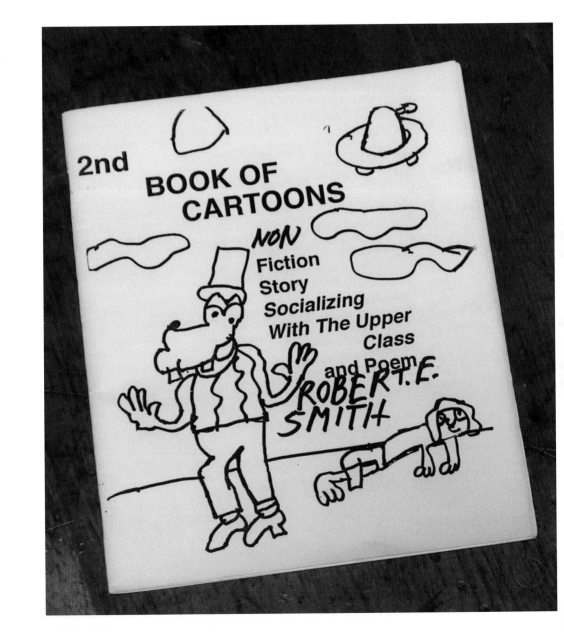

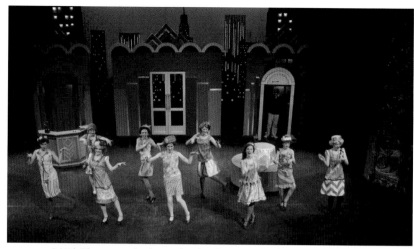

A Little Theater production on Landers Stage. Smith often imaged himself performing.

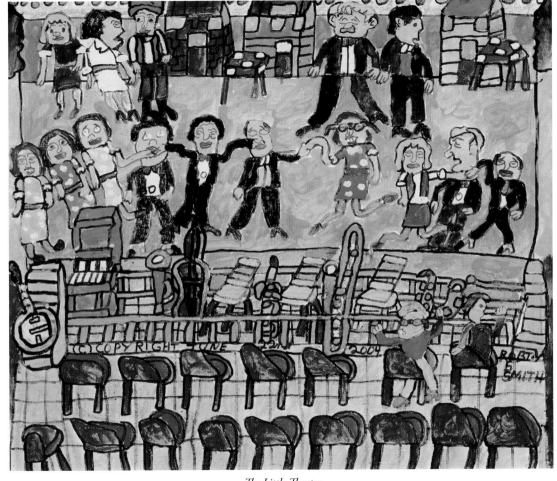

The Little Theater
2009
mixed media, 24 × 20"
from the collection of Jeff and Marcia Johnson

Nighttime In the Forest

It was nighttime in the forest;
The moon, the stars and the trees—
were a fascinating sight.
Then suddenly over by a tree stump
A little wild dog gave me a fright.
The dog howled and a dinosaur walked by
Walking, I almost stepped on a
snake and wished I could fly
The flowers in the forest
were in color and pretty bloom
A donkey walked by and gave me a little room.

The color at night
was a beautiful sky,
The moon, a bird and
spaceship passed me by.
Concluding the nighttime-
view were old, giant trees—
The bark on the trees
Seemed to say don't touch please.
The leaves in the forest
made a roaring sound
I was sleepy and
soon was homeward bound
The mountains in the night
were charming and capped with snow—
Amen partner, wind blowing
hated that temperature zero.

From Robert's self-published *Book of Poems*.

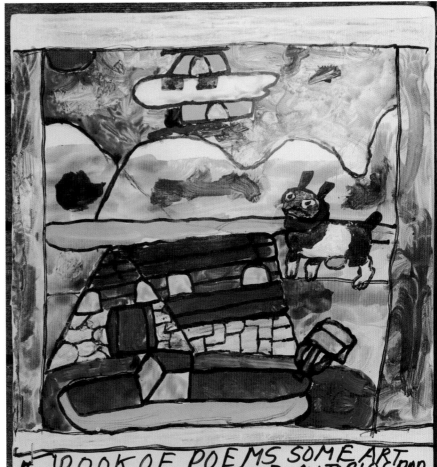

$5.00 BOOK OF POEMS SOME ART
ILLUSTRATION AND AUTOBIOGRAPHY
AND ARTICLE BY ROBERT
E. SMITH
PUBLISHED DECEMBER
1987

Caldwell, Dave. "On Display at UMKC." *Kansas City Star.* 18 June 1980.

Carter, Will. "Springfield, MO Artist Passes Away Leaving Many Memories Behind." *KSPR News.* Springfield, MO. 14 Feb. 2010.

Degener, Patricia. "Folk Art Comes from Hearts and Hands." *St. Louis Post-Dispatch.* 24 Feb. 1984.

Flemming, Paul. "Painter Robert E. Smith is Hanging in There." *University of Missouri-Columbia Graffiti.* 5 Apr. 1985.

Goodwin, Juliana. "Robert E. Smith: The man, the paintings." *Springfield News-Leader.* 15 Feb. 2010.

Gordon, Ellen, Barbara R. Luck, and Tom Patterson. *Flying Free.* Williamsburg, VA: The Colonial Williamsburg Foundation, 1997.

"Guileless Visions: Paintings by Robert E. Smith" August 19-September 30, 1984. Springfield Art Museum. Greg G. Thielen, curator.

Hocklander, Sony. "Life's tales artfully told." *Springfield News-Leader.* 12 Mar. 2000.

Hoffmann, Donald. "Art Journal." *Kansas City Star.* 17 Nov. 1985.

Loeb, Richard, M.D. "Artist Robert E. Smith." *Greene County Medical Society Bulletin* Aug. 1999.

Mason, Randy, Michael Murphy, and Don Mayberger. *Rare Visions and Roadside Revelations.* Kansas City: Kansas City Star Books, 2002.

"Muffled Voices: Folk Artists in Contemporary America" May 16-Sept. 12, 1986. Museum of American Folk Art. New York City. Didi Barrett, guest curator.

Nixon, Bruce. "Folk Art Exhibit Shows Dark Side of Religion." *Dallas Times Herald.* 30 Apr. 1987.

Place, Linna Funk. "Written Word: Add Coherence to Folk Art Exhibition." *Forum* Jan/Feb 1987.

Prince, Dan. *Passing in the Outsider Lane.* Boston: Journey Editions, 1995.

Rosenak, Chuck and Jan Rosenak. *Museum of American Folk Art Encolpedia of Twentieth Century American Folk Art and Artists.* New York: Abbeville, 1991.

Sain, Cliff. "Beloved Springfield 'outsider' artist Robert E. Smith dies at age 82." *Springfield News-Leader* 15 Feb. 2010.

Sellen, Betty-Carol, with Cynthia J. Johanson. *Self Taught, Outsider, and Folk Art.* Jefferson, NC: McFarland, Inc., 2000.

Smith, Robert E. *Best Artist: The Autobiography of Robert Eugene Smith.* Springfield, MO. Self-published, 1998.

Plein, Chad. "Springfield artist Robert E. Smith is not just remembered but is unforgettable." *KY3 T V News.* Feb. 2010.

Stone, Eden. "Untrained Artists Exhibit at Fine Arts." *University News.* University of Missouri-Kansas City. 26 June 1980.

Volkersz, Willem. "Smith's Paintings are Drawn from Experience and Observation." *Forum Magazine* Jan/Feb. 1987.

Whitley, Chris. "Artist revs up '65 Ford in his own way." *Springfield News-Leader.* 12 Dec. 1986.

"Word and Image in American Folk Art." 1986 Mid-America Arts Alliance, Kansas City. Willem Volkersz, curator.

"BIRDS TASTE GOOD!"

Robert E. Smith